WILD AND CRAZY

PHOTOS FROM THE COMEDY WILDLIFE PHOTOGRAPHY AWARDS

Edited by Paul Joynson-Hicks and Tom Sullam

With Alexandra Petri

SIMON & SCHUSTER

New York London Toronto Sydney New Delhi

Simon & Schuster
1230 Avenue of the Americas
New York, NY 10020

First Simon & Schuster hardcover edition October 2017

SIMON & SCHUSTER and colophon are registered trademarks of Simon & Schuster, Inc.

For information about special discounts for bulk purchases, please contact
Simon & Schuster Special Sales at 1-866-506-1949 or business@simonandschuster.com.

The Simon & Schuster Speakers Bureau can bring authors to your live event. For more information or to book an event, contact
the Simon & Schuster Speakers Bureau at 1-866-248-3049 or visit our website at www.simonspeakers.com.

Interior design by Ruth Lee-Mui

Manufactured in China

1 3 5 7 9 10 8 6 4 2

Library of Congress Cataloging-in-Publication Data is available.

ISBN 978-1-5011-7413-1
ISBN 978-1-5011-7414-8 (ebook)

We would like to dedicate this book to all the people around the world

trying to make our planet a better place through their conservation work.

How did it all begin? Our kids often ask.

Allow us to take you back two and a half years to Usa River, just outside Arusha in Northern Tanzania, only hours away from the Serengeti, one of the world's most spectacular ecosystems. This is where Paul Joynson-Hicks lives with his family. As a seasoned wildlife photographer, he is passionate about these wild areas, observing the importance of these fantastic creatures being around for his children and their children in turn to witness. That is a big part of why he created the Comedy Wildlife Photography Awards. Well, that and the fact that he loves funny animal pictures!

It was a dark and stormy night . . . or more likely a steaming hot African day when, after entering yet another futile photography competition, Paul realized that there was no award that celebrated funny

animal pictures. Through a profound love for the wild and the huge disappointment at never being recognized for his funny animal pictures, the Comedy Wildlife Photography Awards were born.

Paul built a little creaky and obstinate website, solicited the help of a few wonderful judges, found some amazing sponsors and, bang, off it went. He received superbly funny submissions from far and wide: from the USA to the UK, India to South Korea, and even as far as Australia and New Zealand. Newspapers and media outlets wrote about the award.

The next year, in 2016, in his infinite wisdom, Paul invited Tom Sullam on board, a friend and a fellow photographer, who was already a judge. Unfortunately for Paul, Tom had managed to win a couple of photo competitions already, something of a sticking point between them. Indeed, this was certainly no marriage made in heaven. One was funny; the other one didn't think so. One was talented; the other one didn't think so. But what these two did share was a love for the environment, wildlife, and the general well-being of the planet.

That year, Paul and Tom drew more submissions, and more attention. Since we launched the competition two years ago we have received a whopping 3,500 terrific entries, making the judging stages of the competition extremely difficult. We have included those winners along with some of our favorite photographs in these pages.

This book hopes to raise awareness about the animals—and areas—of the world that are in serious danger. For example, if we carry on at the rate that we are going, there is a very high chance that rhinos and

elephants will no longer walk this earth in fifty years. To observe such majestic beasts and to know that, unless we drastically change our habits, they will completely disappear, is utterly heartbreaking. Sadly, it is not just these massive creatures, but many, many more species that are in danger.

We have partnered with the Born Free Foundation, a national animal advocacy nonprofit, to help us spread that message. They work tirelessly to protect wildlife around the globe. Their mission is to keep wildlife in the wild, and they hope to put an end to entrapment and return captive animals to their natural habitat.

We give 10 percent of all the revenue we receive as the Comedy Wildlife Photography Awards straight to them. That's right: by buying this book, you have already embarked upon your wonderfully enlightened journey to becoming a conservationist.

There's more you can do, too. Again, that's where the Born Free Foundation comes in. They can help you decide how to help. You may be able to volunteer in your local area to help conserve woodlands or perhaps pick up litter. Or, if time is limited, you could donate to the Born Free Foundation and become part of their family, just as we did. We've included resources for how to help in the back of this book.

We hope these funny animal pictures make you laugh. They made us laugh, and they made us admire the beauty and diversity that is on offer to us in the world today. But we also hope the images inspire you to join us in our efforts to protect these funny—and vulnerable—animals.

Thank you.

Paul and Tom

BUT DOCTOR, JUST A WEEK AGO THIS WAS

both ends of the beast

ONLY A PIMPLE ON MY BOTTOM,

murmured simultaneously.

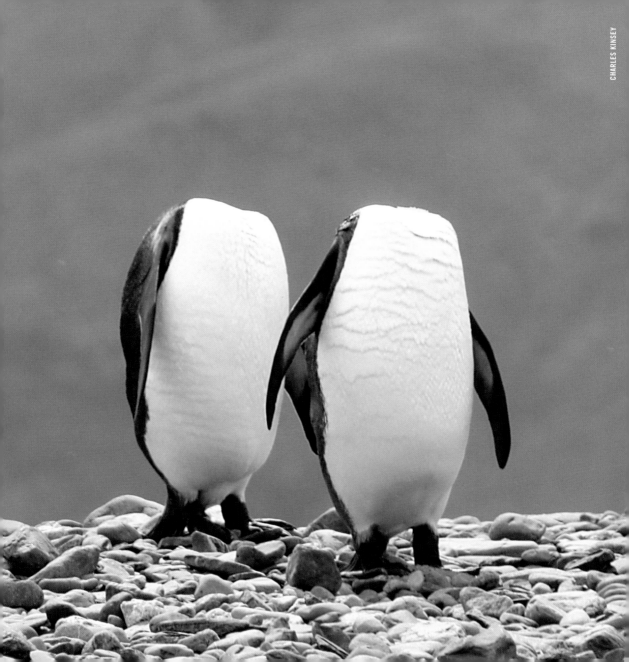

Keith and Michael's ostrich parents had never found a good time to tell them that they were adopted.

Everything the light touches,

Kyle whispered.

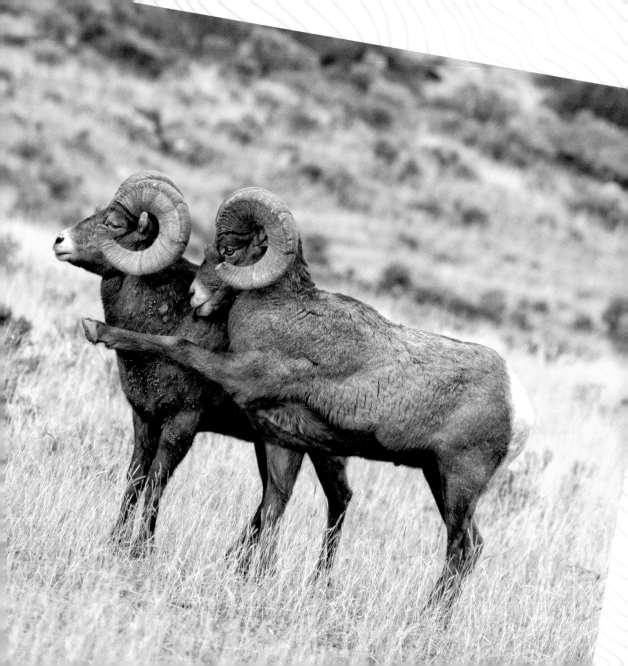

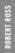

Don't do yoga.

The consequences can be dire.

THIS SQUIRREL HAS COMMITTED
AN ACT OF SHAME AND
ITS PURITAN COMMUNITY
IS PUNISHING IT.

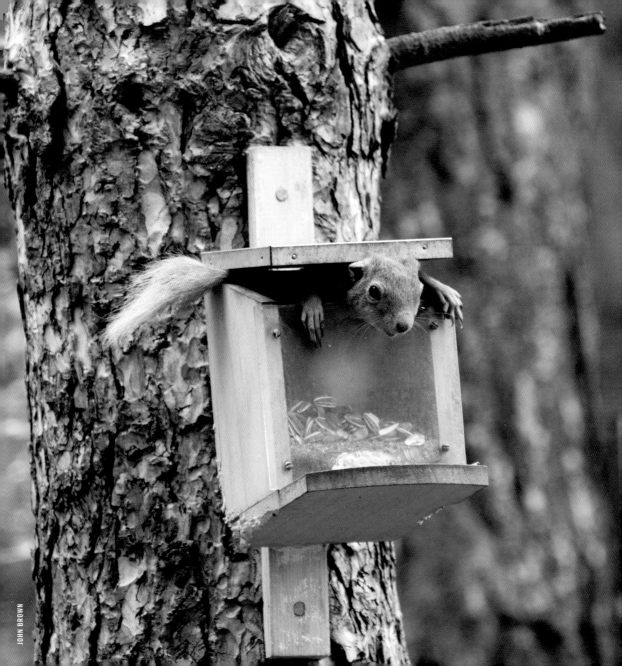

A real

WHO'S HOO.

Claude was an okay singer but he was not the

GOAT.

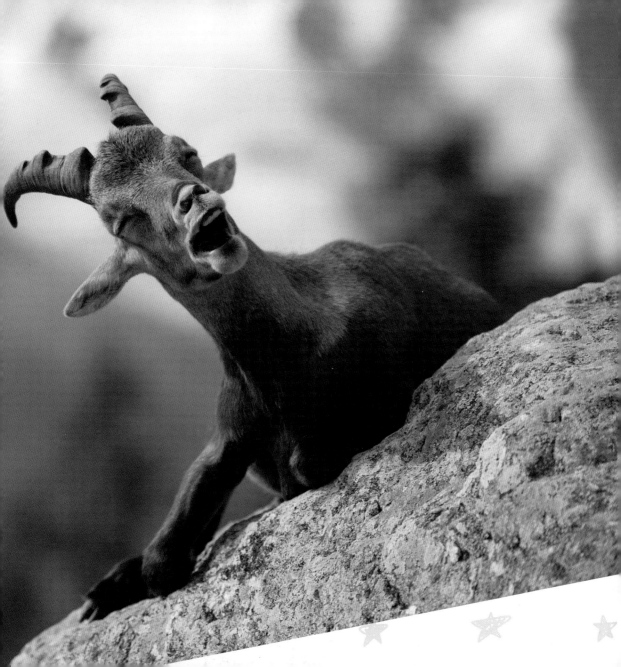

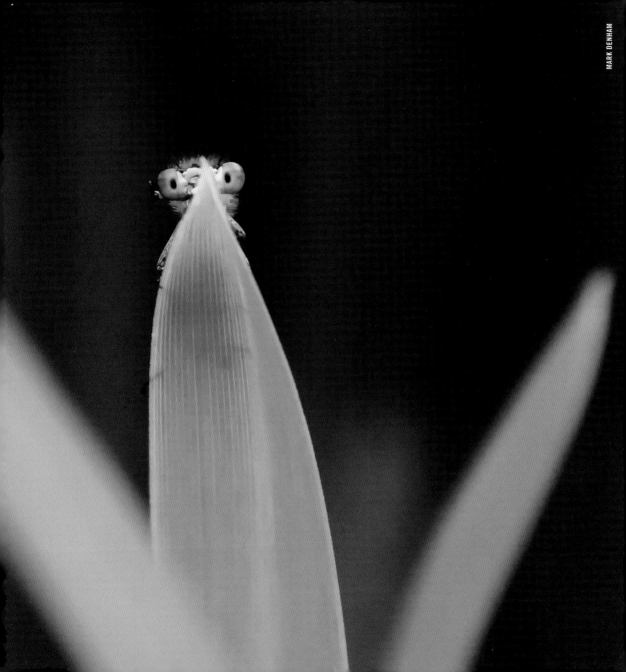

PHOTOBOMB.

d'oh

a deer.

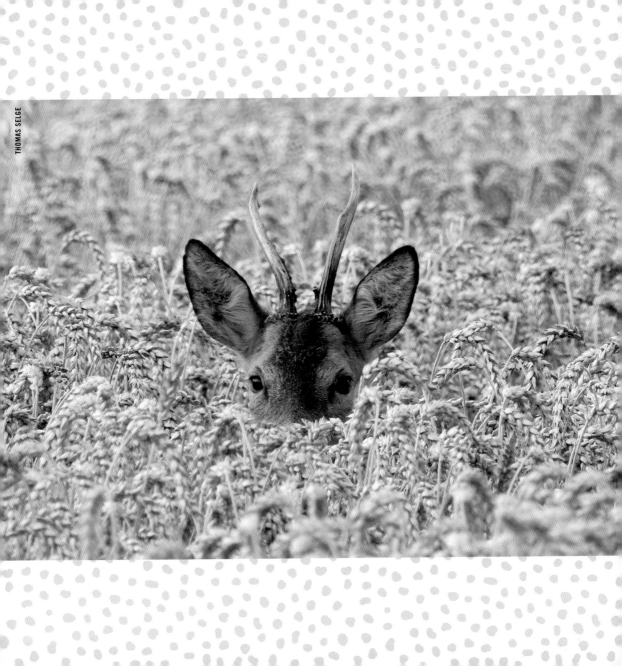

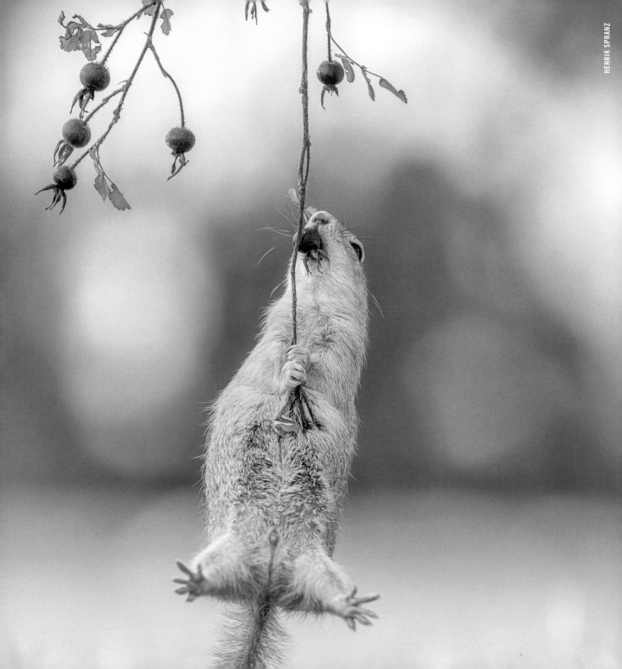

SHUT UP,

I'VE GOT THIS.

EVERYTHING YOU'VE BEEN TOLD ABOUT

THE BIRDS AND THE BEES IS A

LIE.

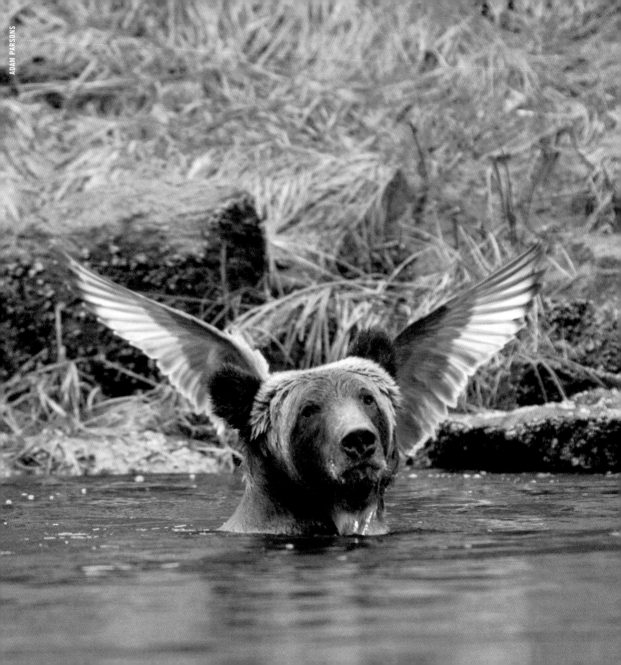

Typical FOX Viewer.

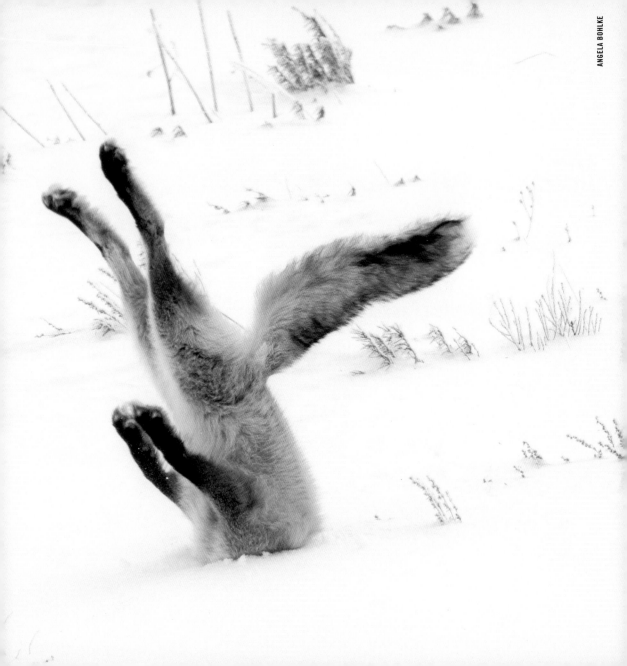

Every so often Damon would remember any interaction he'd ever had socially in his life and cringe with his entire body.

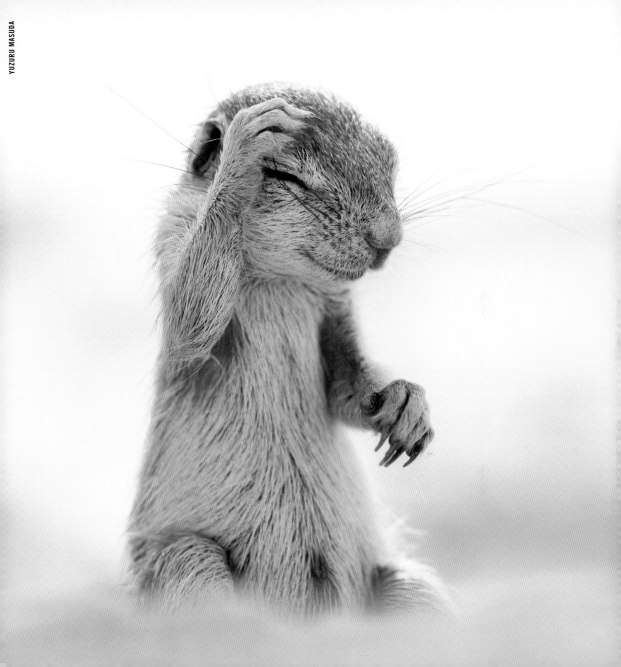

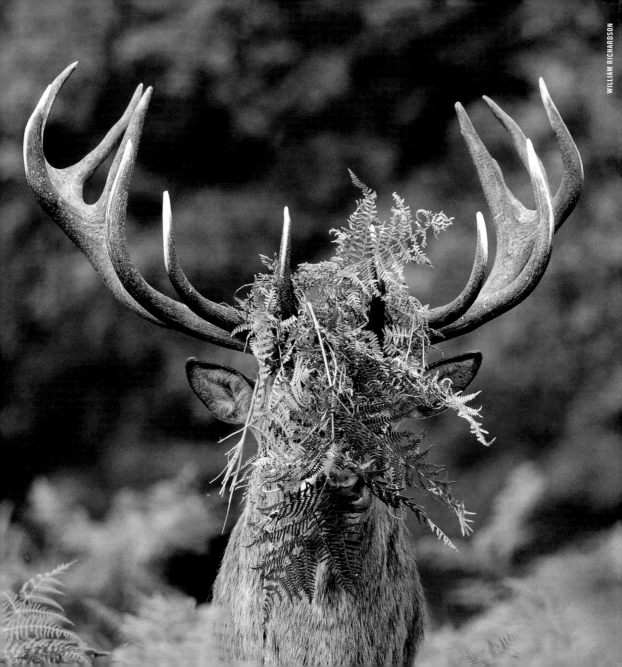

Clement's Stag Night was becoming a nightmare.

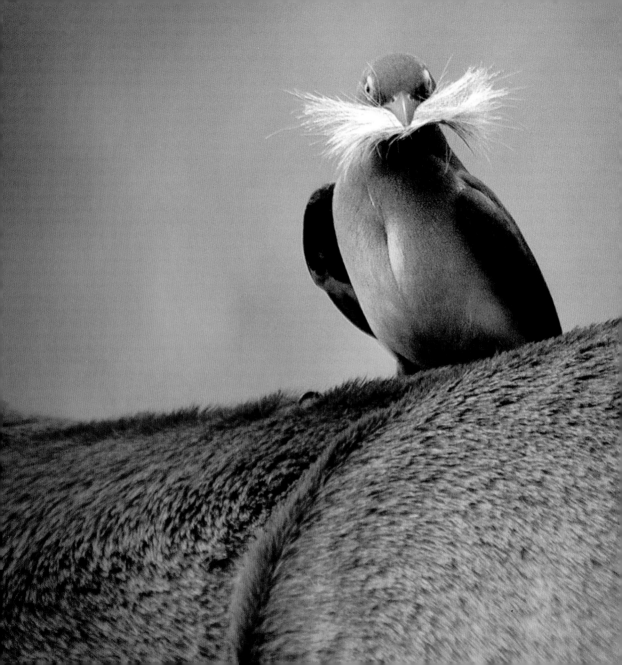

Bird likes big butts;

cannot lie.

Other tree frogs hate this couple for constantly posting cute selfies in their luxurious tree home. It's like, we GET IT, Tina—your life is PERFECT.

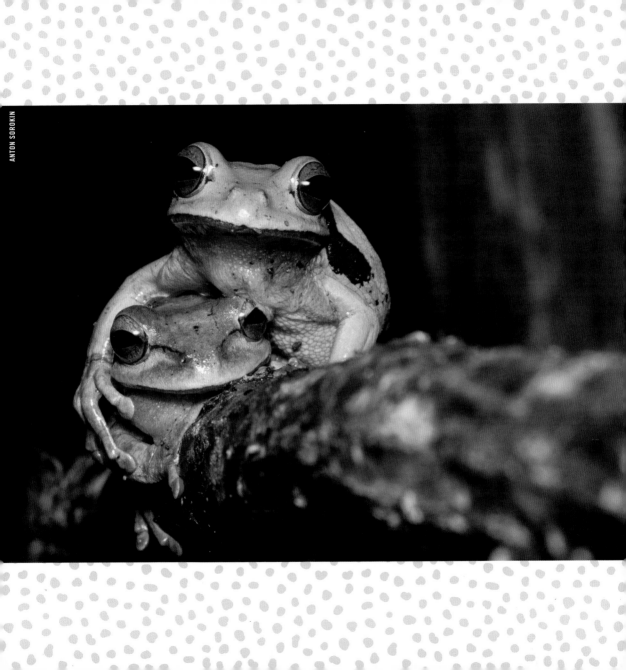

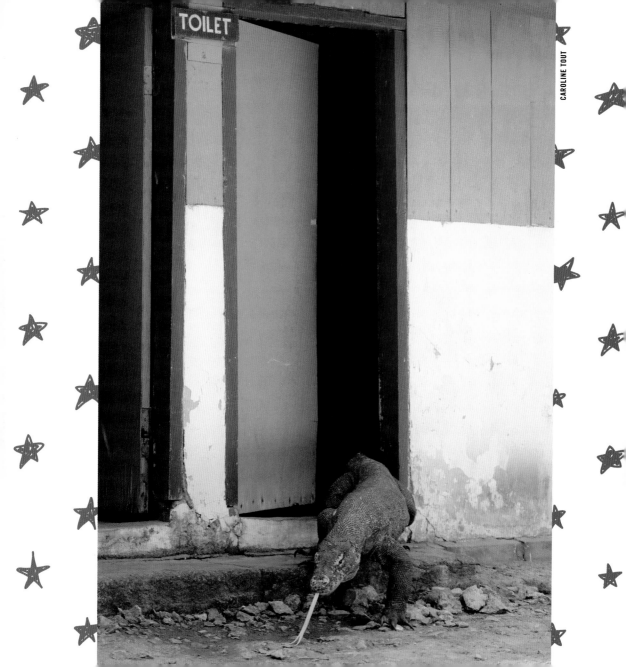

TOILET

OOOF!

Sorry, no one had better go in there for a couple of hours.

Dangerous carnivore demands belly rub.

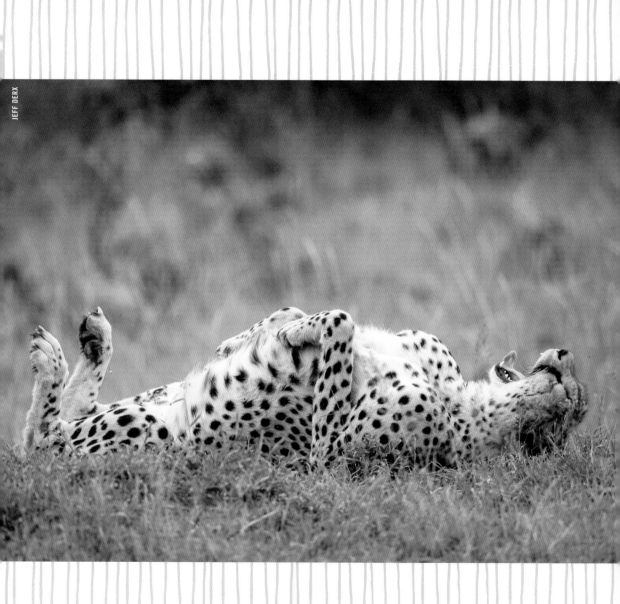

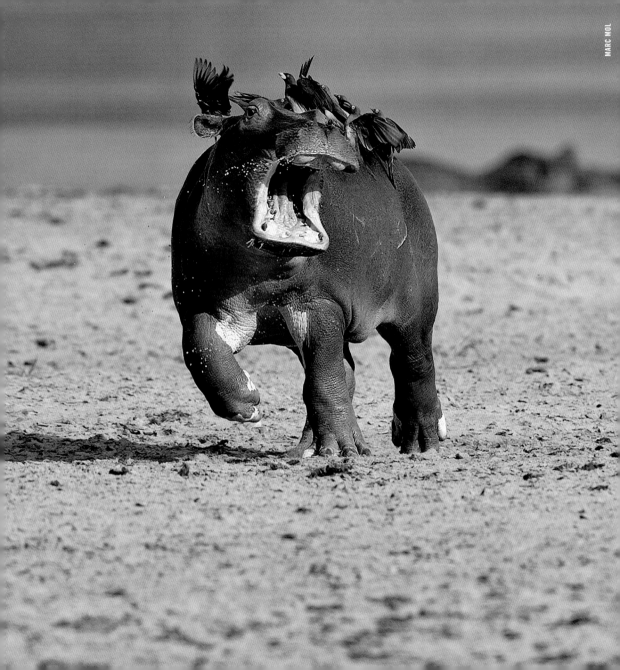

OH GOD

GET IT OFF

GET IT OFF.

Do you have ants
in your pants?

Well, do you want to?

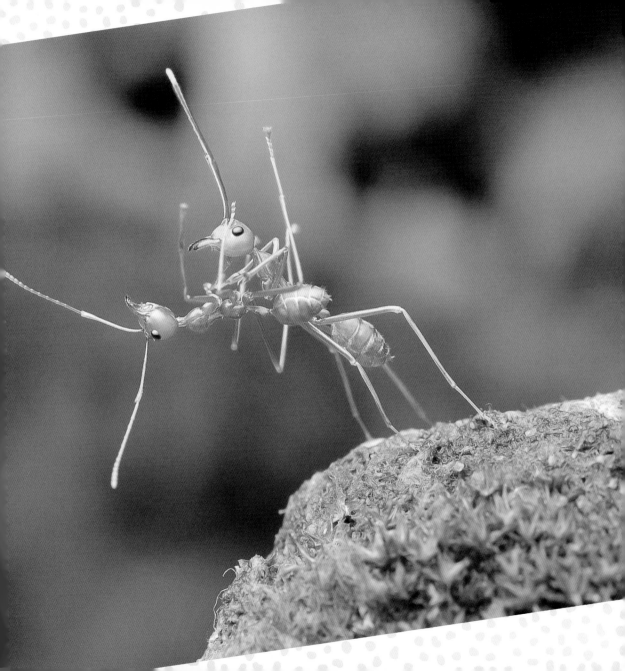

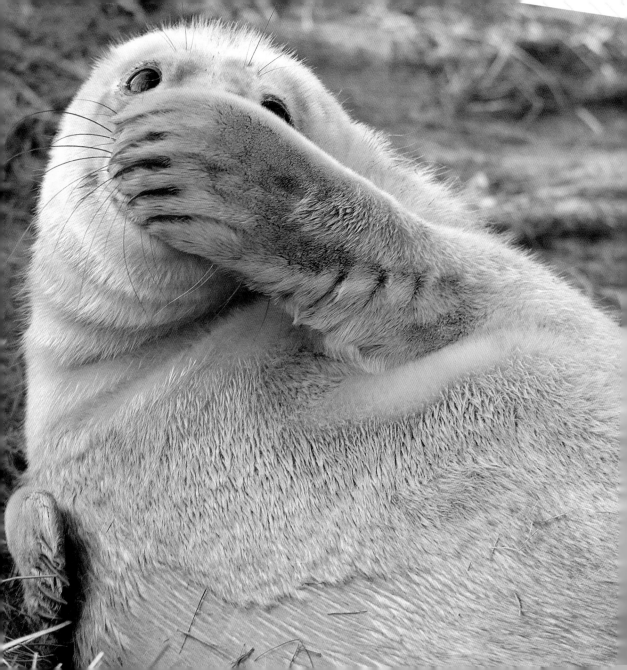

BOOP.

GODDAMNIT, GOLDILOCKS!

GET BACK HERE!

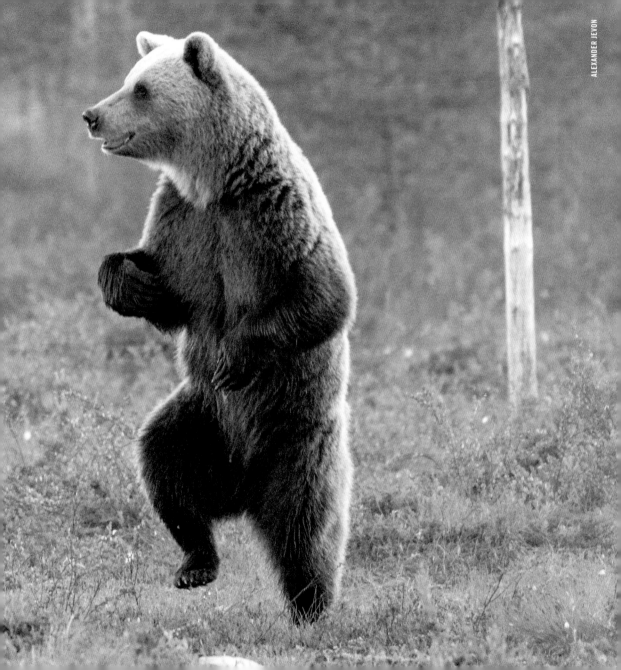

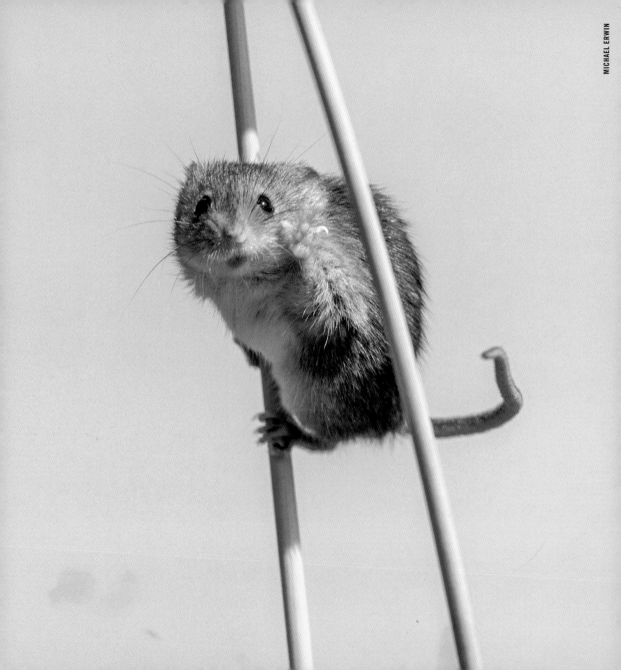

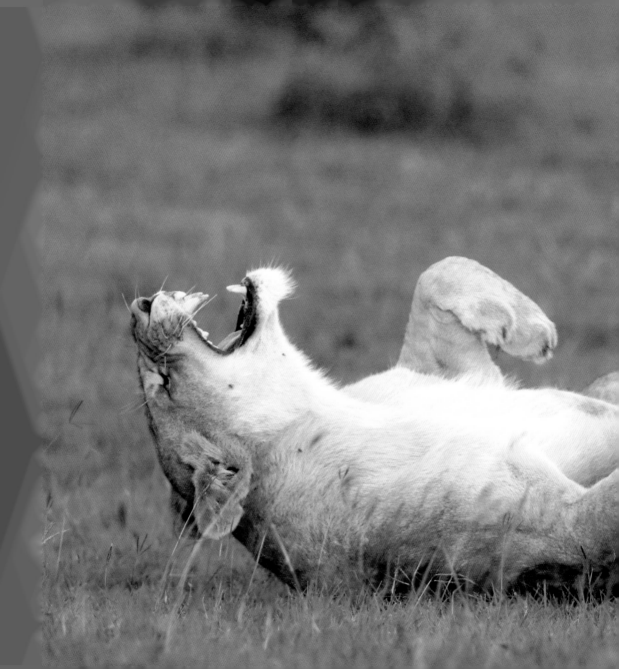

Two lionesses sharing an in-joke.

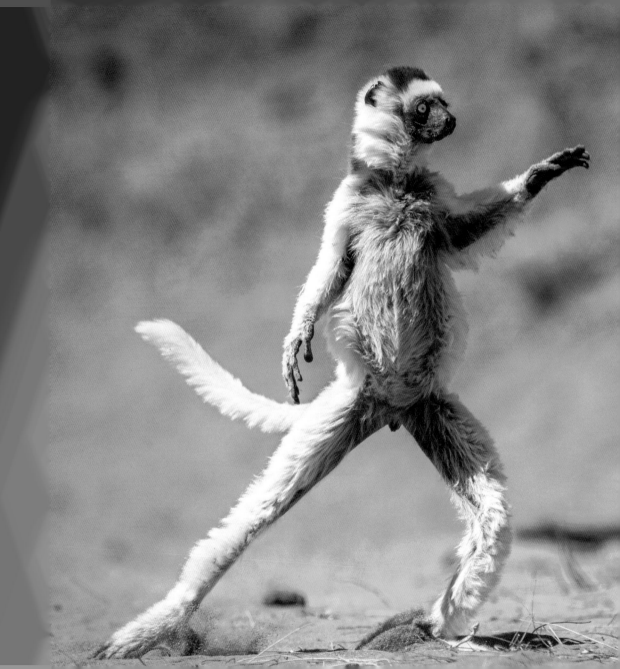

**Disco took a long time
to reach Harold.**

THESE GIRAFFES ARE NECK AND NECK!

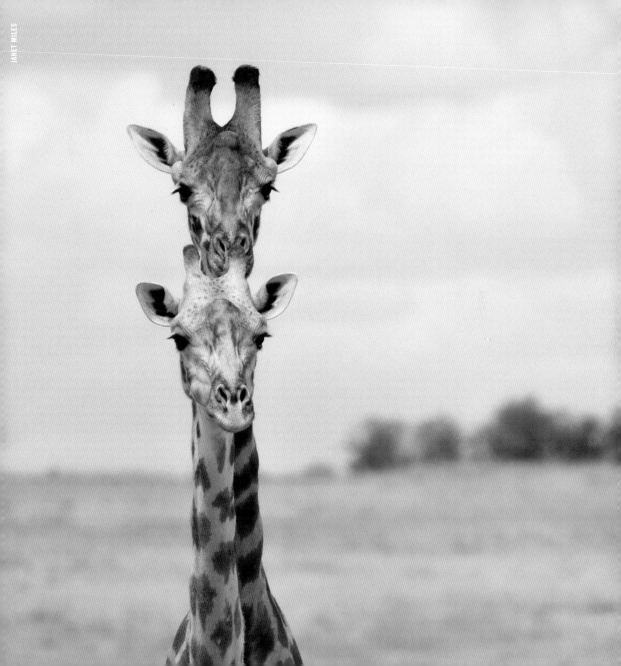

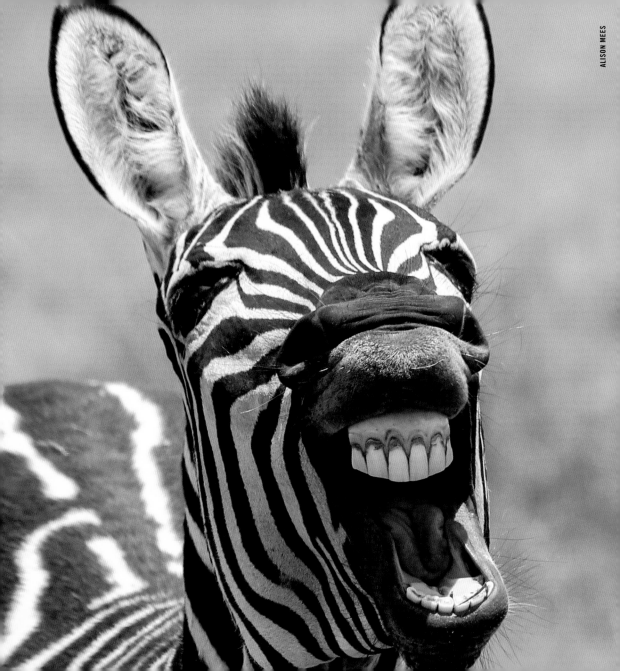

That's where my grandfather's dentures went.

Vacation selfie.

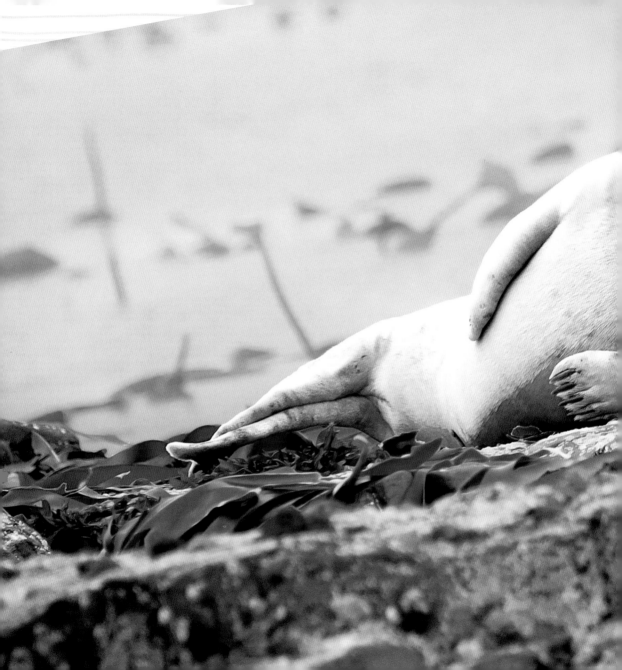

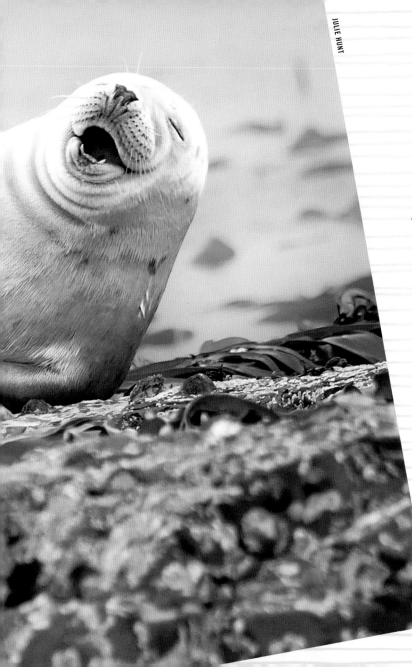

This seal has just

told a sexist joke.

This is a hostile work environment.

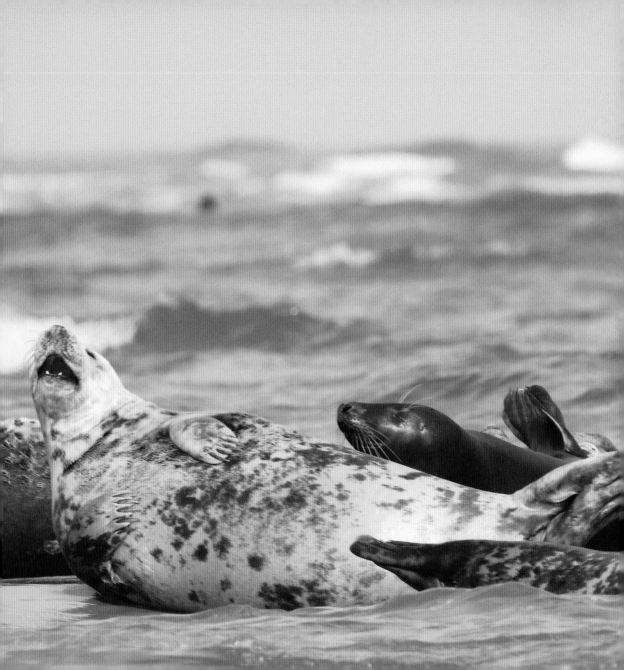

No one ever listened to Tiffany.

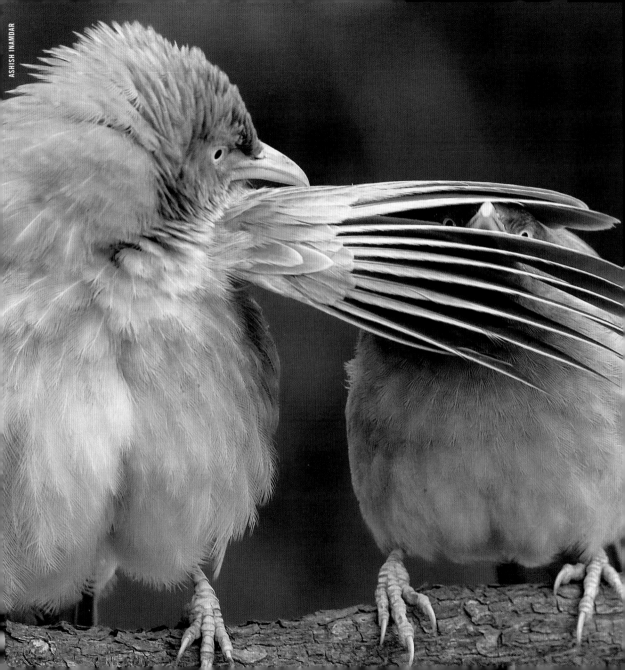

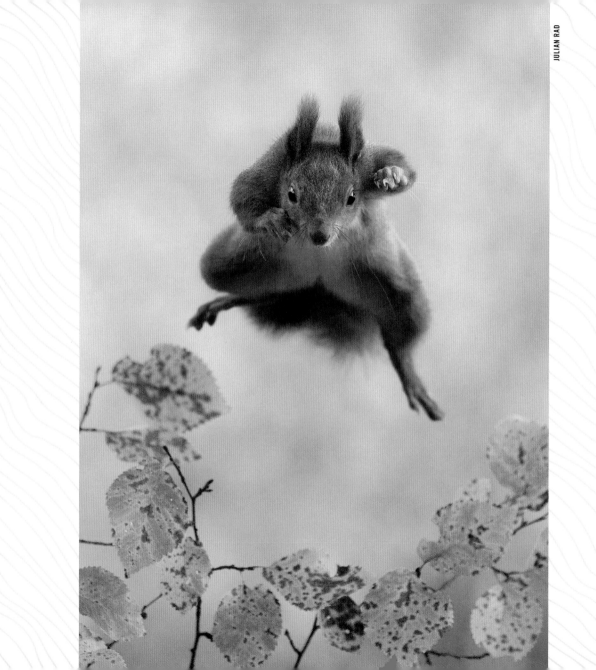

It's going to suck for Susan when she learns she is not, in fact, a flying squirrel.

Rare footage of leopards
performing the Heimlich in the wild.

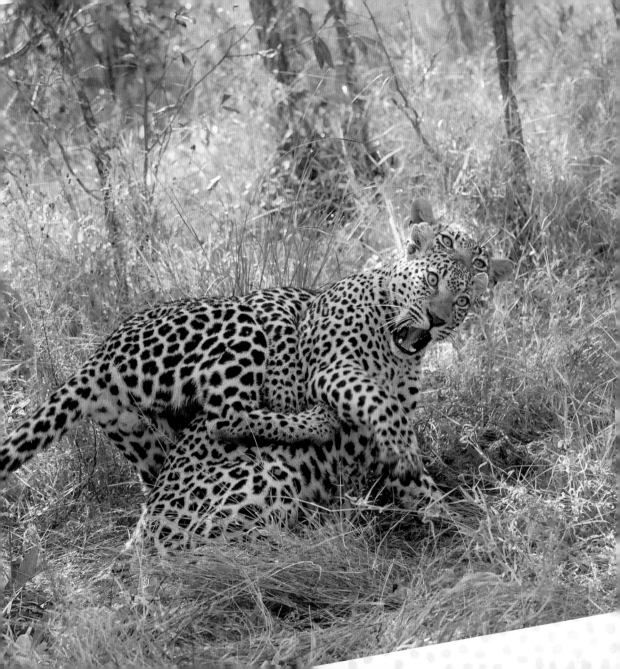

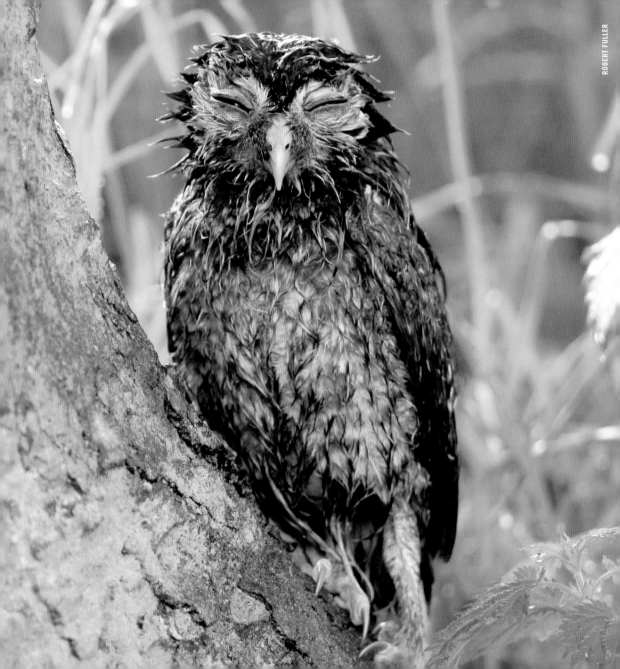

CONVENTIONAL BEAUTY STANDARDS ARE A PRISON.

I *will* turn this car around.

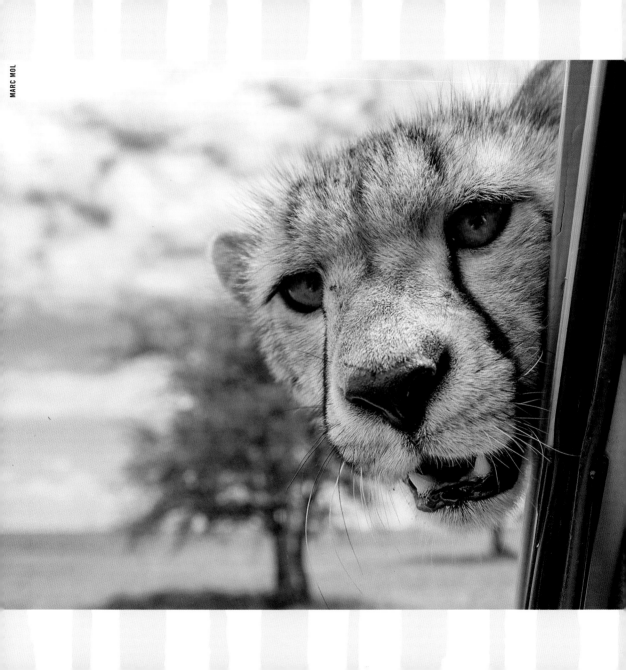

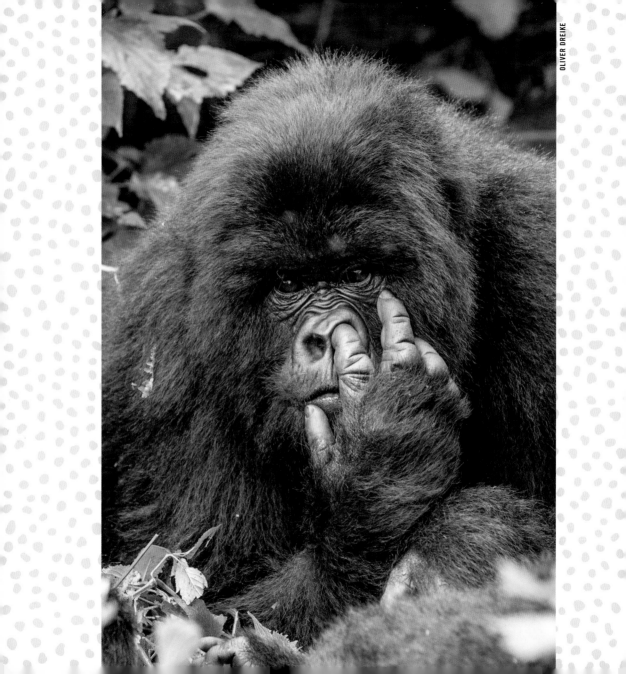

What are the odds that a photographer
of another species will be lurking to
catch me picking my nose?

Gently, gently for the first movement.

Now woodwinds.

Then timpani, softly, before the strings come in.

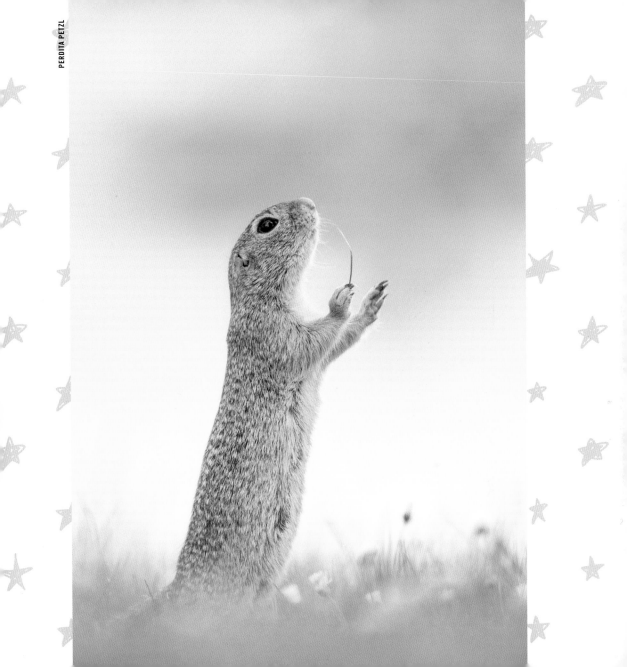

Oh no, I missed my lunch again.

First day of New Year's resolution to jog.

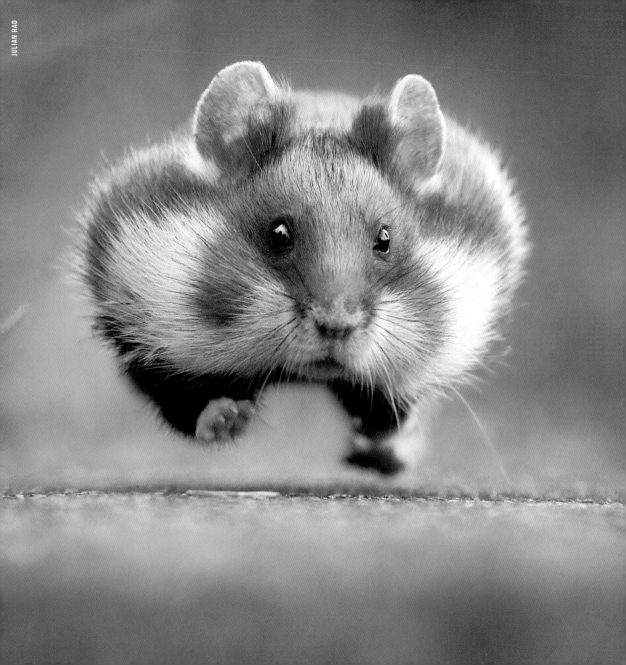

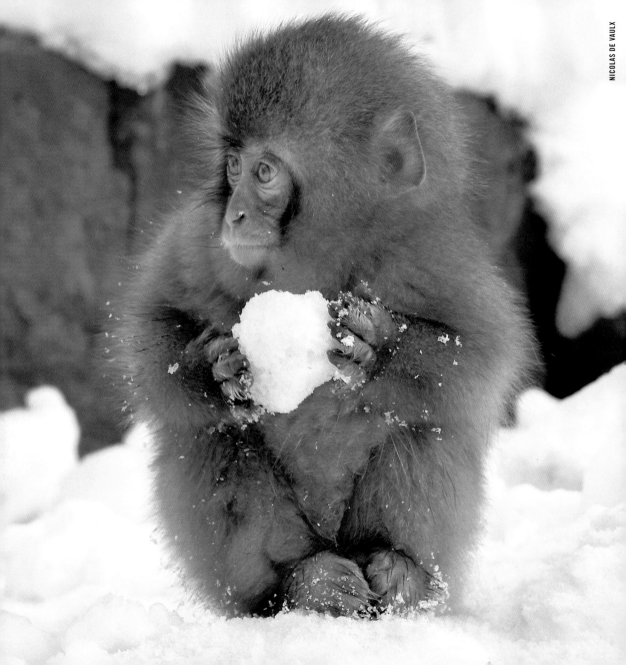

Do you want to build a

snow macaque?

This Tinder profile is trying too hard.

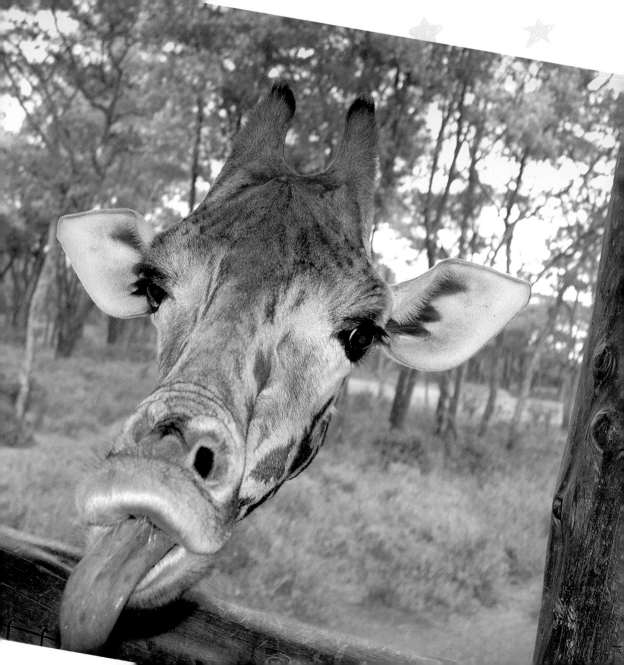

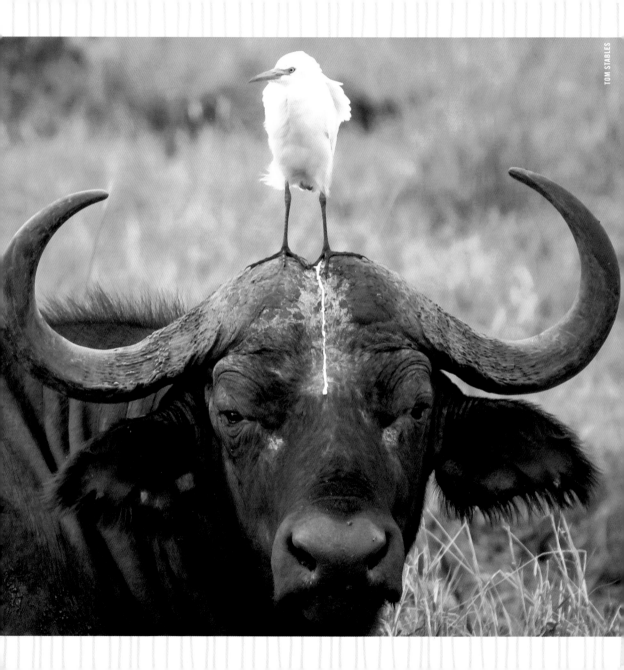

I HATE MONDAYS.

Cheetah observes the speed limit.

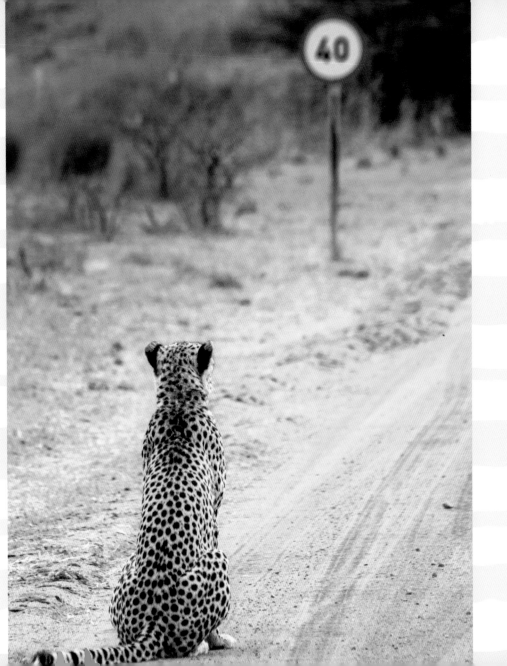

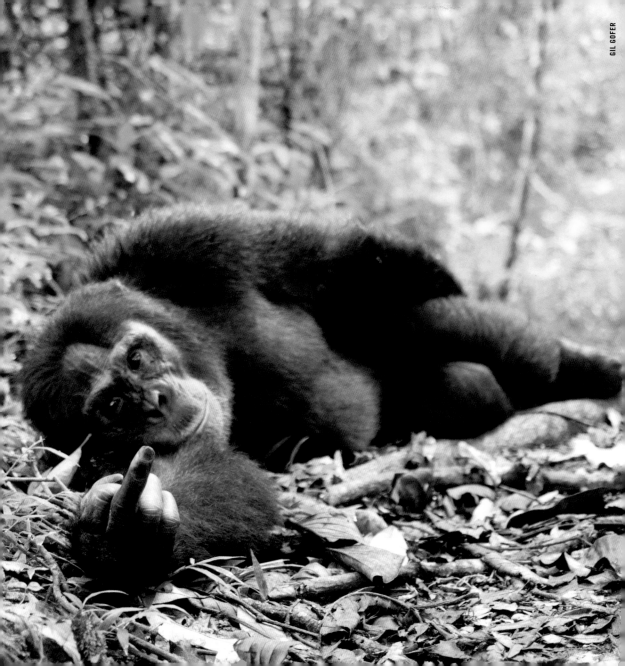

I SAID,
PAINT ME LIKE ONE OF
YOUR FRENCH GIBBONS.

Look, I exercised this morning.

It's fine.

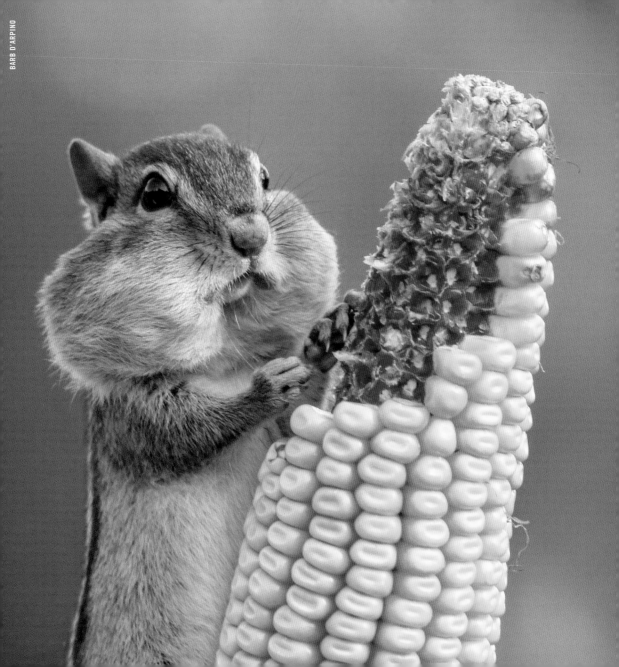

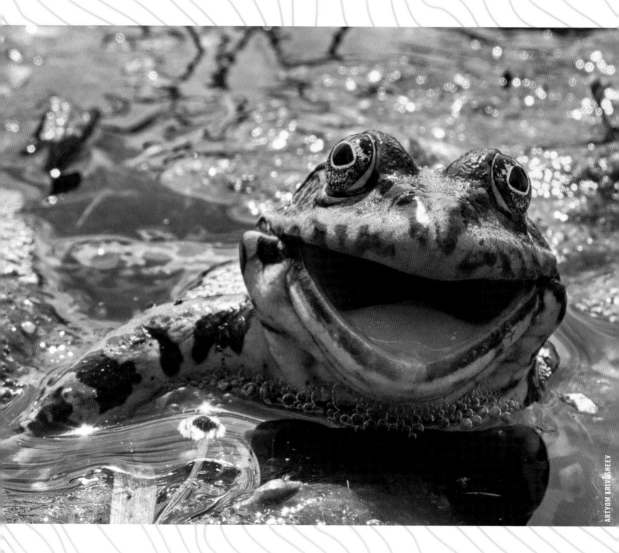

When he gets you back to his pad.

When was the last time
you flossed, Michael?

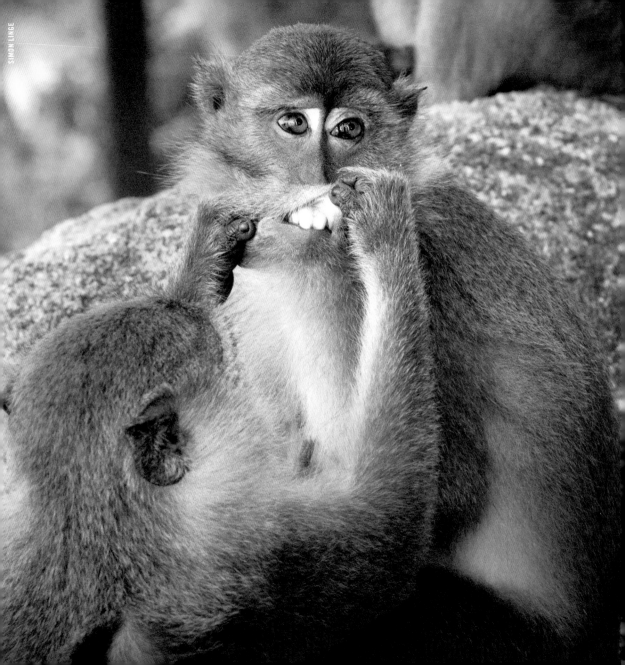

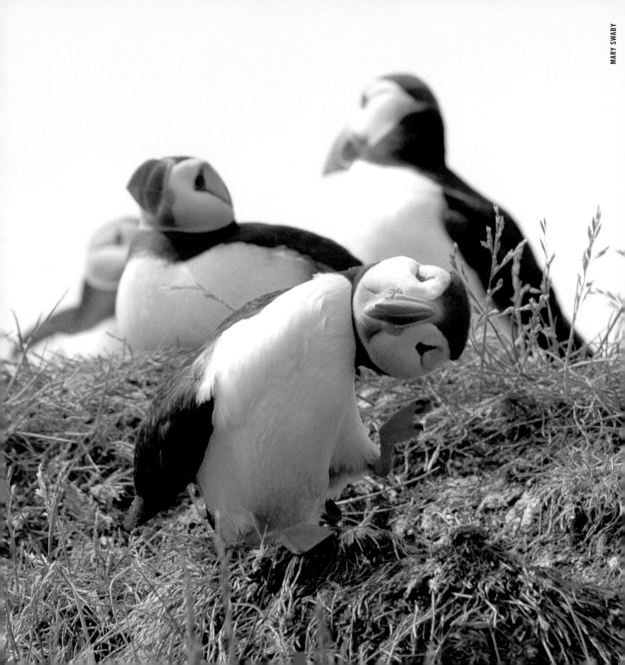

Of course I'm SMOKIN'.

I'm a PUFFIN.

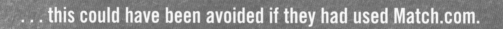
. . . this could have been avoided if they had used Match.com.

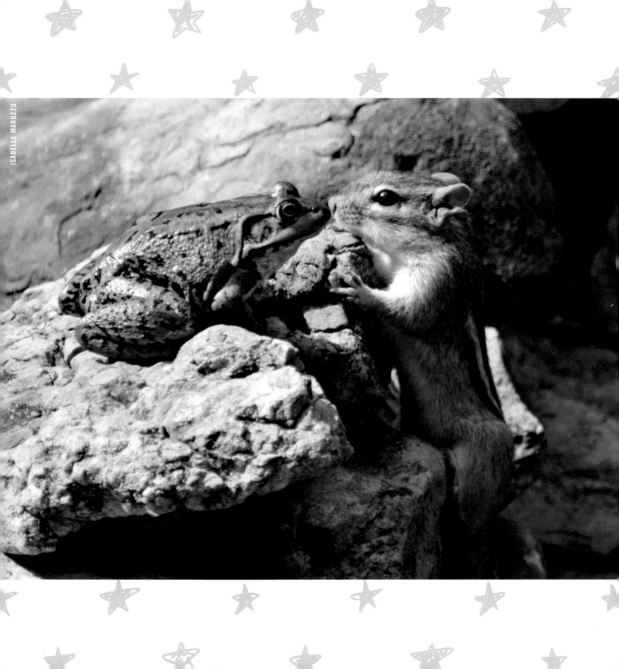

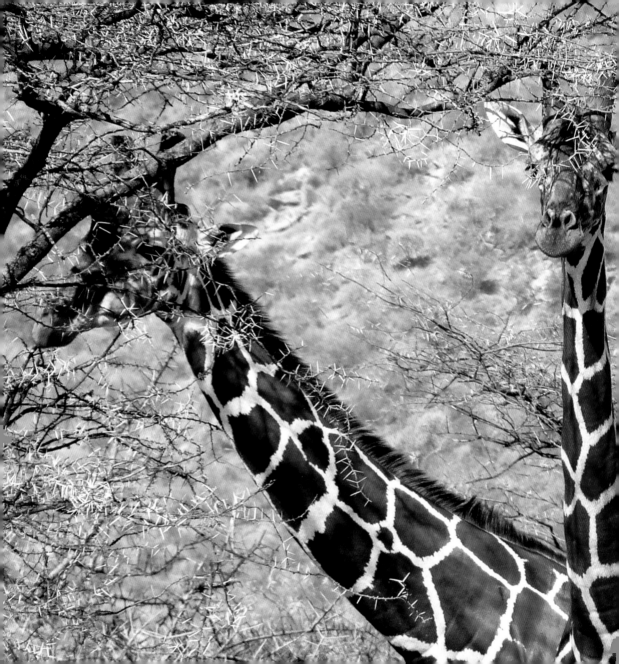

WHEN SHALL
WE THREE
MEET AGAIN?

IN THUNDER,
LIGHTNING,
OR IN RAIN?

TONY MURTAGH

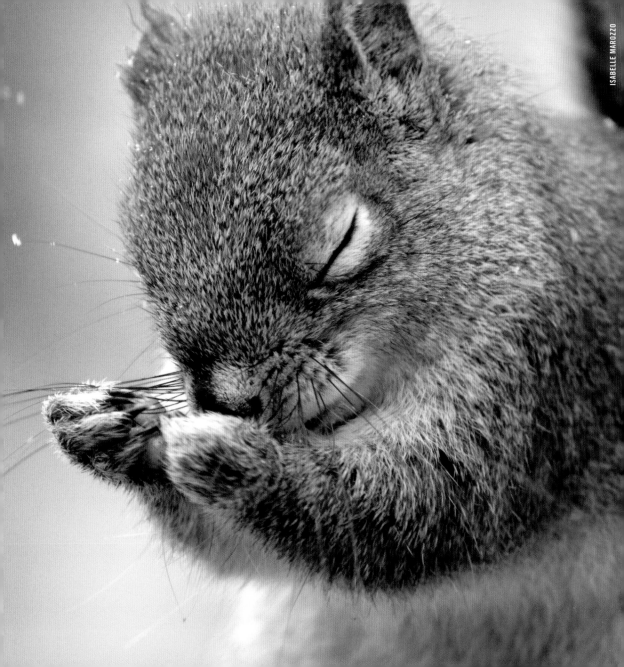

No, no, Henri. You must be strong.

Life comes at you fast.

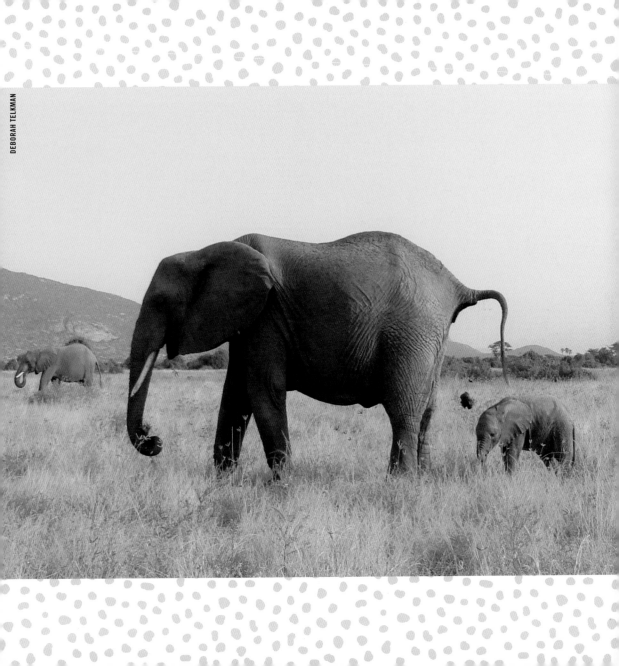

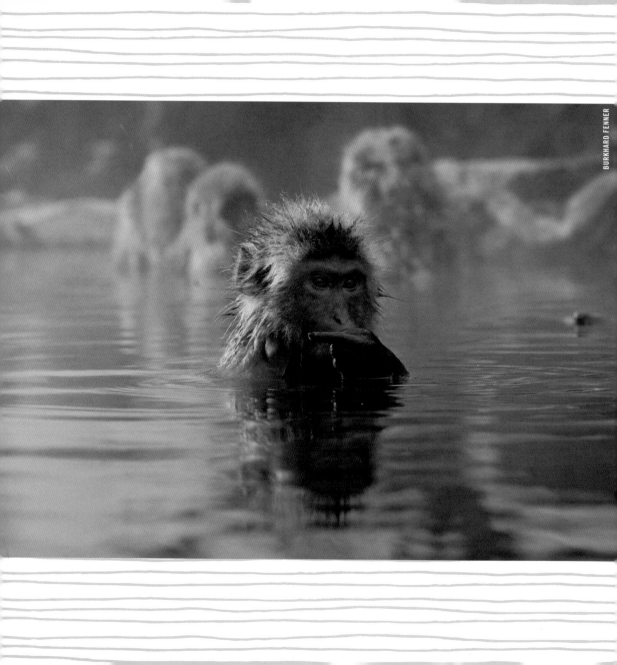

The sauna is that way.

Maurice loved to look at himself in the club picture.

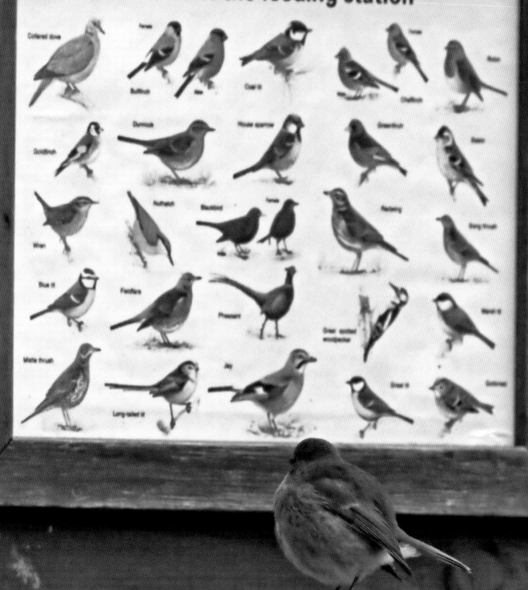

Birds of the feeding station

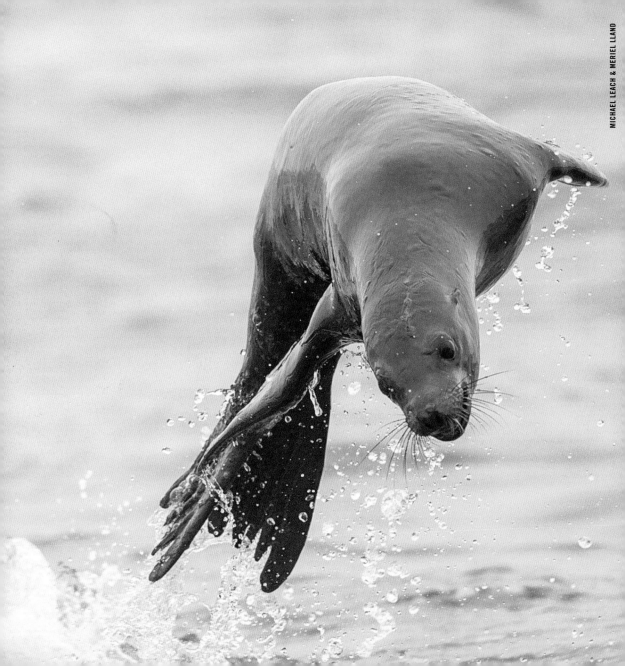

JUDGE #1

4

JUDGE #2

5

JUDGE #3

4

I woke up like this.

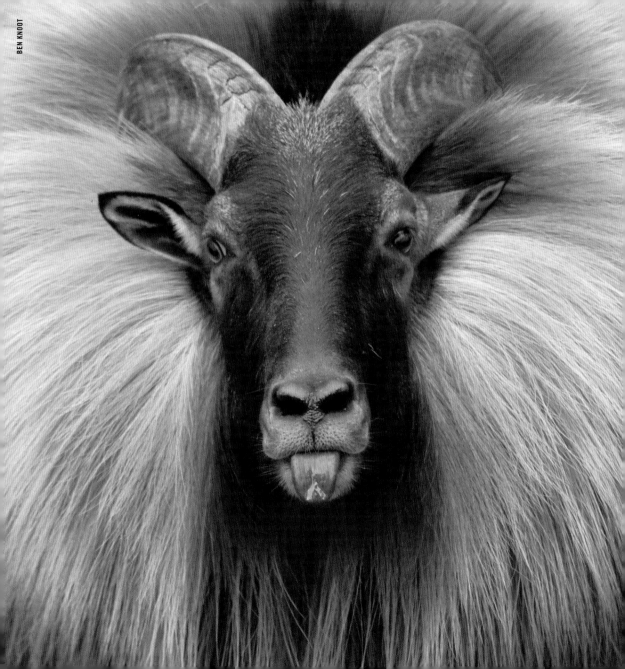

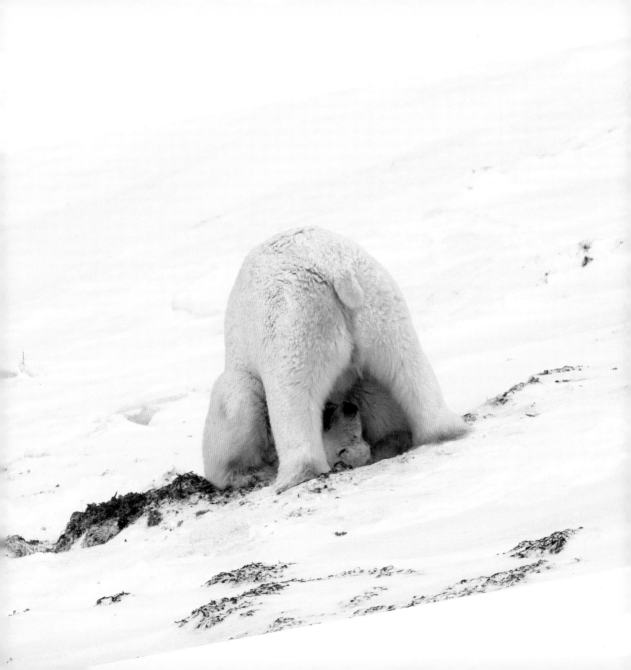

Yoga will make you more flexible,

they said.

SIMON GEE

This bird can't swim.
Or read.

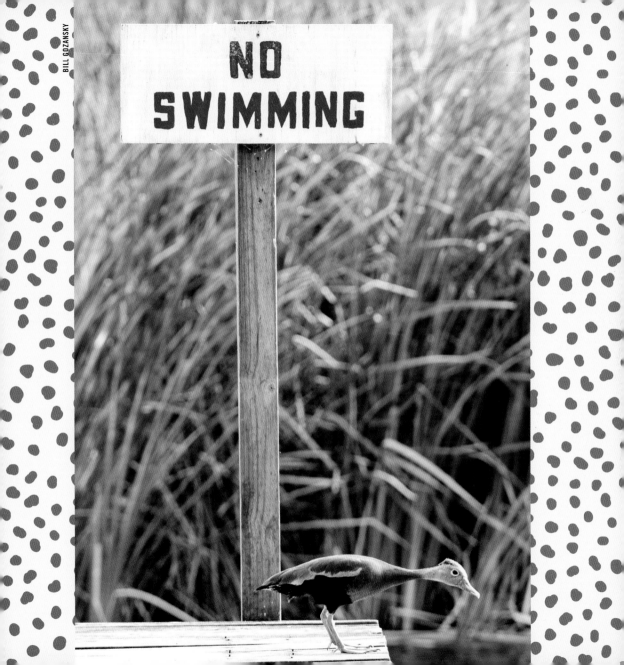

NO SWIMMING

BILL GOZANSKY

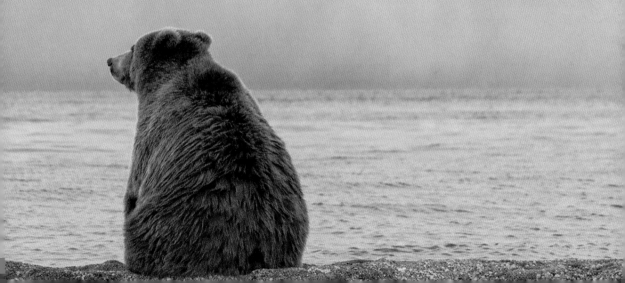

With age, Patricia worried about what others thought of her less and less.

In retrospect, Dustin realized
that bangs were not a good idea.

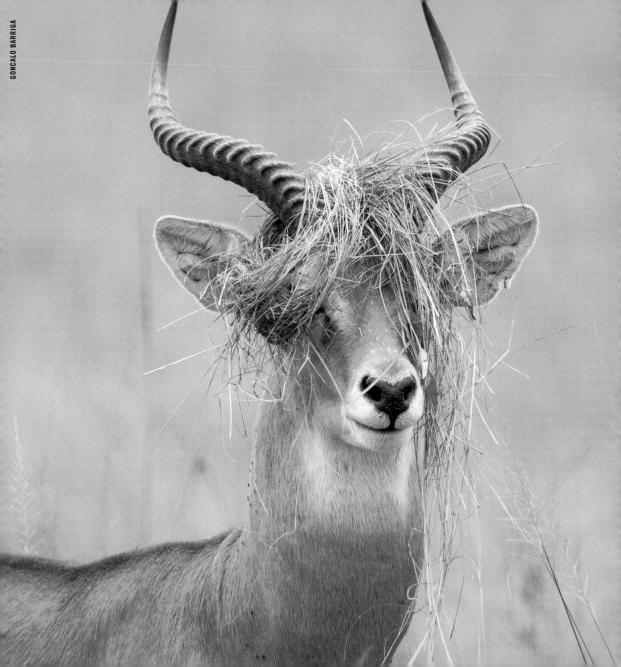

Ugh.

The women's restroom line is always impossible.

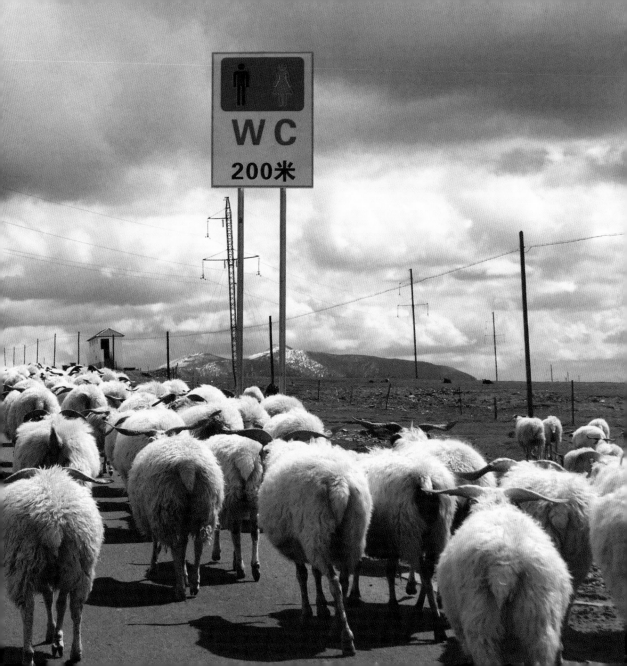

No, Roxane. Romance is not dead.

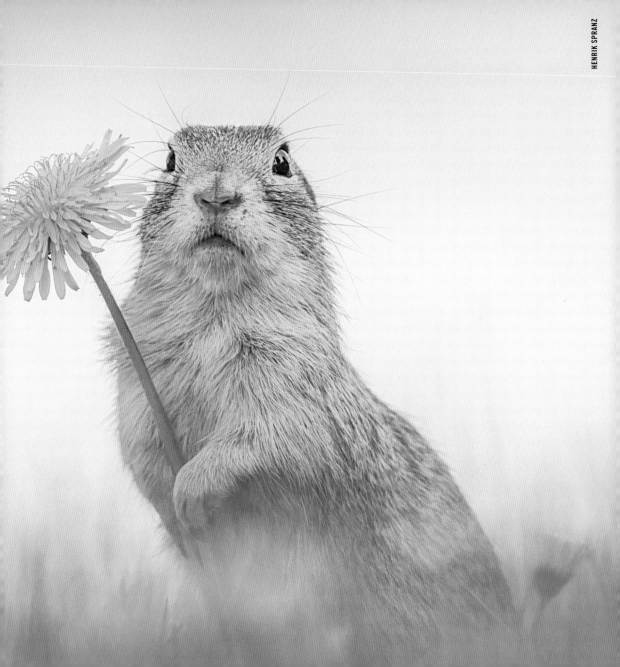

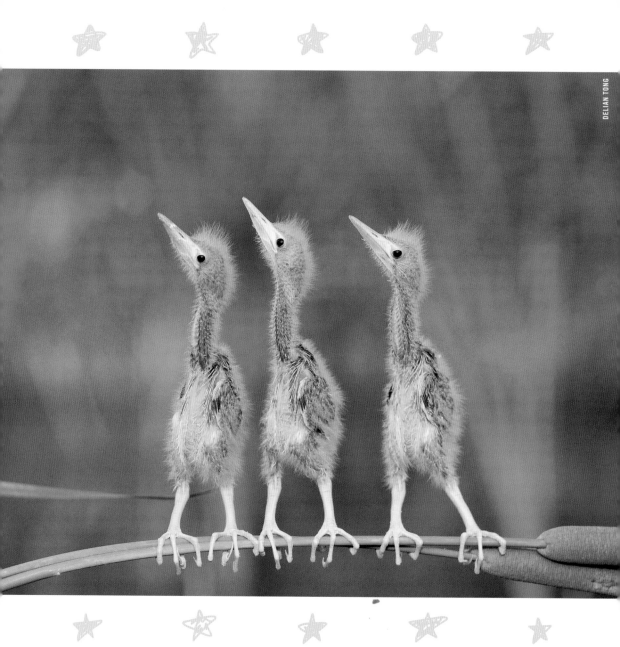

They start these girl groups

younger and younger.

BEARS ARE TAKING
ALL OUR JOBS.

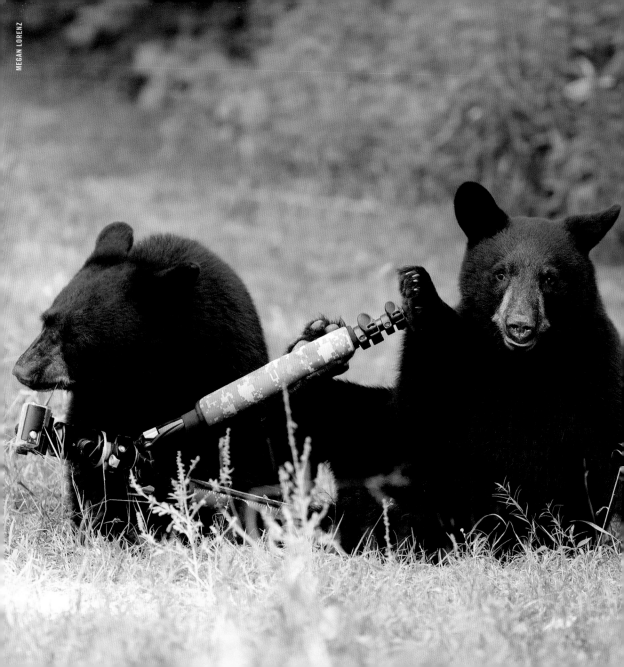

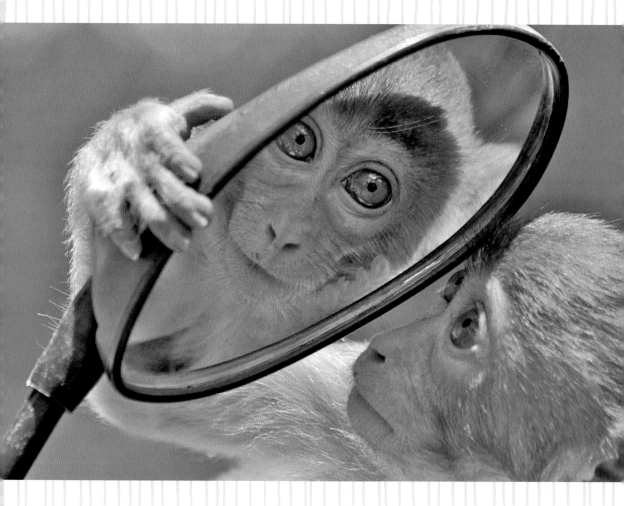

Beauty is in the eye of the monkey holding the mirror.

Sharlene always escalated things.

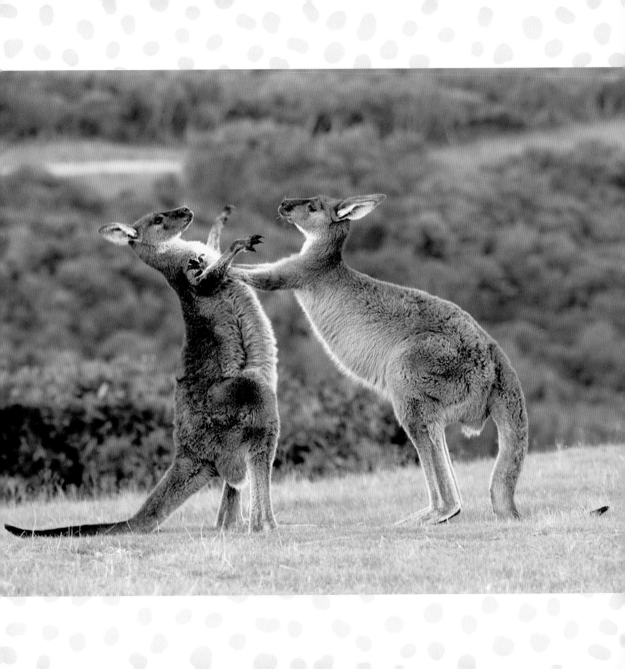

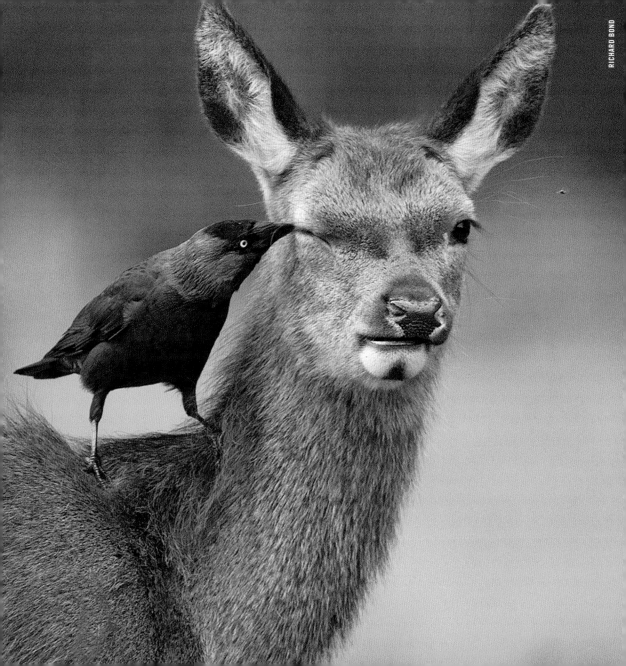

PLEASE STOP HELPING.

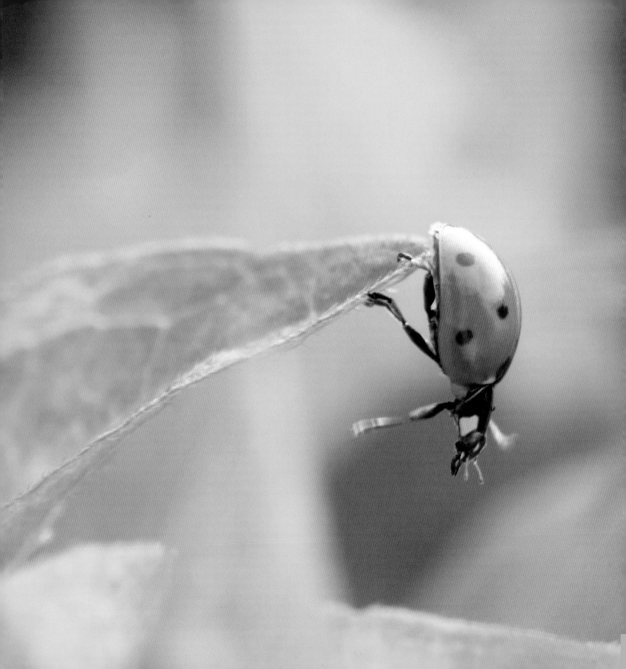

Claire took the phrase

"living on the edge"

a little too seriously.

PETER STANLEY

It sucks being
the big spoon.

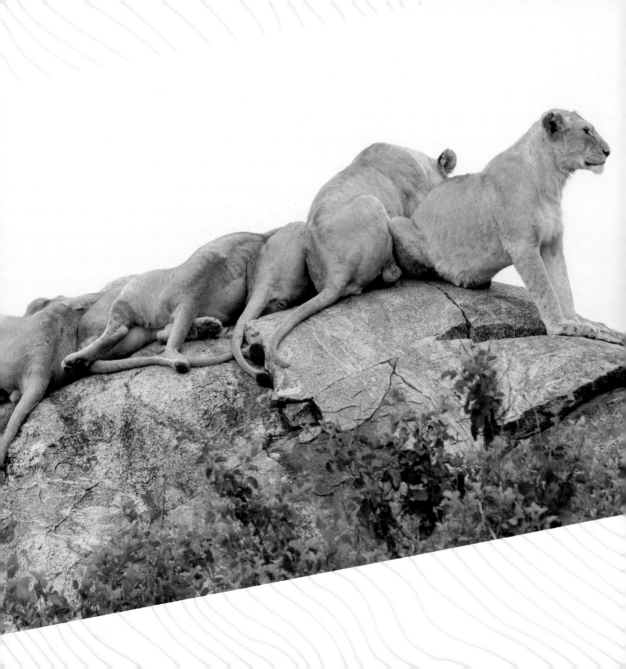

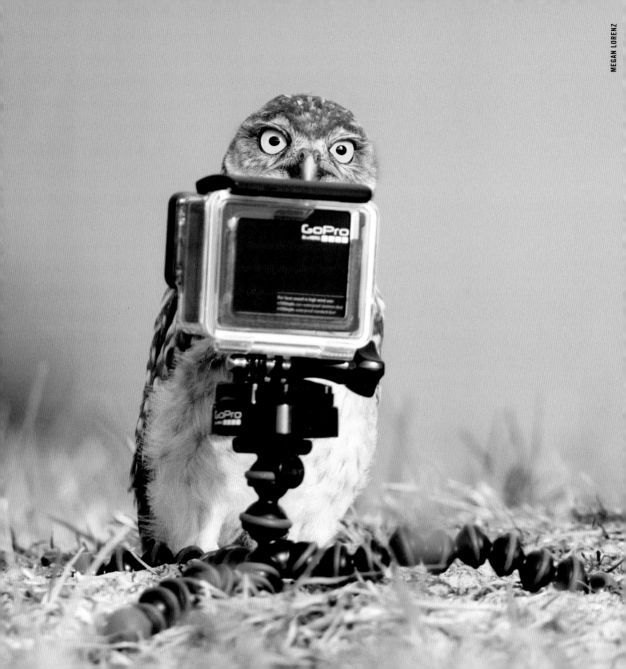

Owl 1: Diane Arbus, who?

Owl 2: WHO?

Owl 1: Never mind.

TAKE ACTION FOR ANIMALS

Not all of us get to see wildlife in the wild where they rightfully belong, but you can help animals no matter where you are.

Here are a few things you can do to help our planet and its wild inhabitants:

1. Communicate with your local, state, and federal representatives. Tell them how you want them to vote on conservation, animal protection, and climate change bills. Representatives listen to their constituents, so make your voice heard. Call, email, or even better, write a letter.

2. Sign up for an email list to stay informed about the issues and learn about proposed legislation that needs your voice. We recommend Born Free USA at www.bornfreeusa.org.

3. Use social media. Follow and support wildlife conservation organizations to stay up-to-date on new legislation, current events, and on what is happening in the field. Show your support by becoming an ambassador and sharing their posts with your friends.

4. Donate. Put some of your hard work toward preserving our planet and our wildlife, so future generations will be able to see wildlife in the wild. You want problems solved, and there are experts who are working to solve them, but they can't do it without funding. Also, look further than what you see on TV. Bigger isn't always better; many small organizations are making a huge impact and putting your donations to work for animals. And, remember, no donation is too small. The most important thing is to give something.

We love Born Free USA. We know them and they use their hard-earned resources extremely well and have made a genuine difference to wildlife across the planet. Both Tom and I have firsthand experience of it.

You can give at www.bornfreeusa.org/donate.

ACKNOWLEDGMENTS

It would be difficult to know where to start these acknowledgments if Paul and Tom had had much support. Sadly, they did this all on their very own, struggling through the multi-disciplined requirements of running a photography competition much like a cheetah struggles to abide by the recent 40-mph speed limit set on his territory.

Seriously, however we are joking. We are over the moon that the Comedy Wildlife Photography Awards has taken off with such aplomb since its inception just two years ago. For that success, we would like to thank several people.

Our judges: Kate Humble, Hugh Dennis, Will Travers, Will Burrard-Lucas, Oliver Smith, and Adam Scorey. The Magnificent Six, all individually bringing their own specialism, skill, and insight to the judging

process, and all elevating the competition to a level it would have struggled to achieve had it been left in our own shaky hands. Thank you, it really has been a pleasure, and we look forward to many more years working with you.

Our sponsors and partners: Born Free Foundation, Amazing Internet, Kenya Airways, Nomad, Alex Walker Serian, Nikon, and last but by no means least One Vision Imaging. The Magnificent Seven this time, and utterly invaluable to the success of this photography competition. To be able to offer the prizes we do, the exhibition, and the website to make it all possible has been a major reason for helping reach so many people and increase awareness of these animals. Thank you to you all for what you have done and what you continue to do.

Our literary agent Natalie Galustian, a fantastic source of knowledge and direction who continues to juggle Paul and Tom's myriad character flaws and help get the show on the road. Which very smoothly leads us on to thanking our publisher, Emily Graff at Simon & Schuster for performing a very similar role to Natalie's!

And finally, though by no means least, to our families—The Pooch, Tommy & Sammy on one side and Kate, JoJo, and Finn on the other side. They have been so tolerant of our late nights, early mornings, and general disappearance acts (to play golf) and not once have they shown any exasperation or doubt in our project. For that we owe them a lot more than we can ever pay back. Thank you.

With much love to all of you,

Paul and Tom

ABOUT THE EDITORS

PAUL JOYNSON-HICKS is a wildlife photographer. He lives in Arusha, Tanzania with his Mrs. (aka the Pooch), his two small boys (aka the Bograts), and his Springers. He loves being in the bush and taking pictures. He has received recognition from the British government for his charitable work in Tanzania over the years.

TOM SULLAM spent the first part of his professional life working in financial services in London before he realized the error of his ways to quit everything in order to pursue a career in photography. He won the prestigious Fuji Photographer of the Year award, along with the One Vision prize. He recently moved with his family to Tanzania where the wilds of African landscapes have provided yet another challenge.

ABOUT THE CONTRIBUTOR

ALEXANDRA PETRI is a gregarious biped seldom spotted in the wild.

The Comedy Wildlife Photography Awards are proud to support Born Free USA, the international wildlife charity founded by Virginia McKenna, Bill Travers, and their eldest son Will Travers following Bill and Virginia's starring roles in the classic film *Born Free*. The charity is devoted to wild animal welfare and compassionate conservation, working to save animal lives, stop suffering, rescue individuals, and protect rare species. Born Free USA is determined to end captive animal exploitation, phase out zoos, and keep wildlife in the wild. They take action for lions, elephants, gorillas, tigers, wolves, bears, dolphins, turtles, and many other animals and work with local communities to find solutions to help people and wildlife live together without conflict.

Find out more and get involved at www.bornfreeusa.org.